Published in 2019 by What the Farce Publishing

COPYRIGHT ILLUSTRATIONS © 2019 BY WHAT THE FARCE PUBLISHING ALL RIGHTS RESERVED. NO PART OF THIS PUBLICATION MAY BE REPRODUCED OR TRANSMITTED IN ANY FORM OR BY ANY MEANS, ELECTRONIC, OR MECHANICAL, INCLUDING PHOTOCOPY, RECORDING OR ANY INFORMATION STORAGE SYSTEM AND RETRIEVAL SYSTEM WITHOUT PERMISSION IN WRITING BY PUBLISHER WHAT THE FARCE.

PRINTED IN THE UNITED STATES OF AMERICA

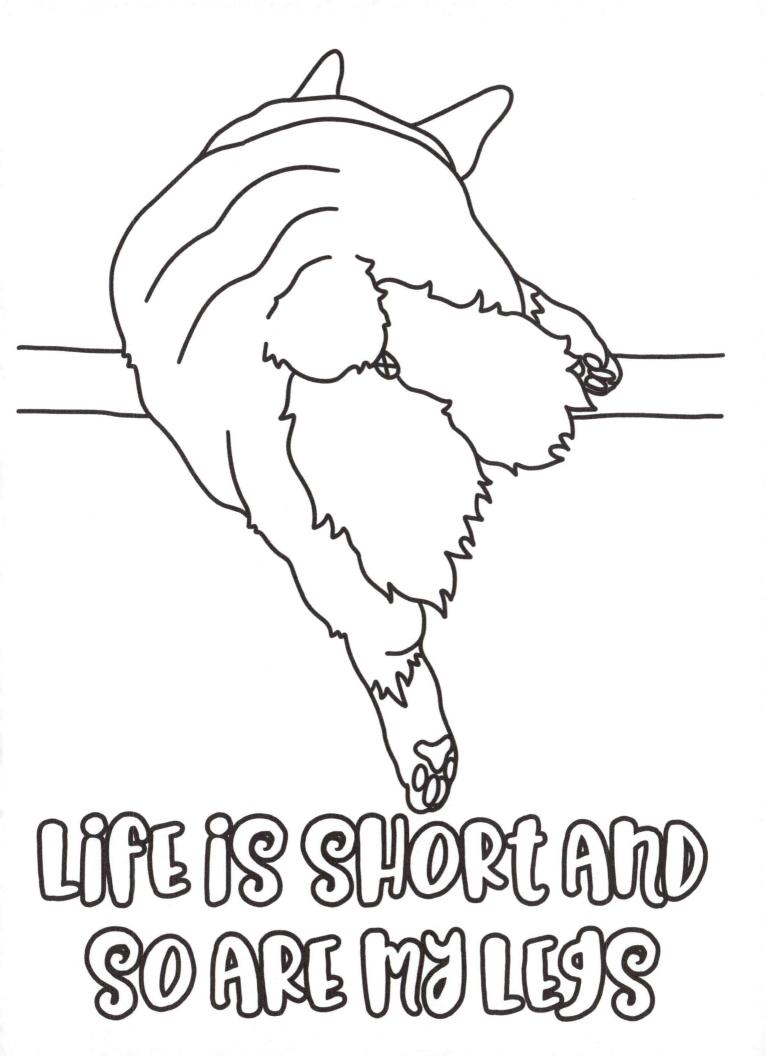

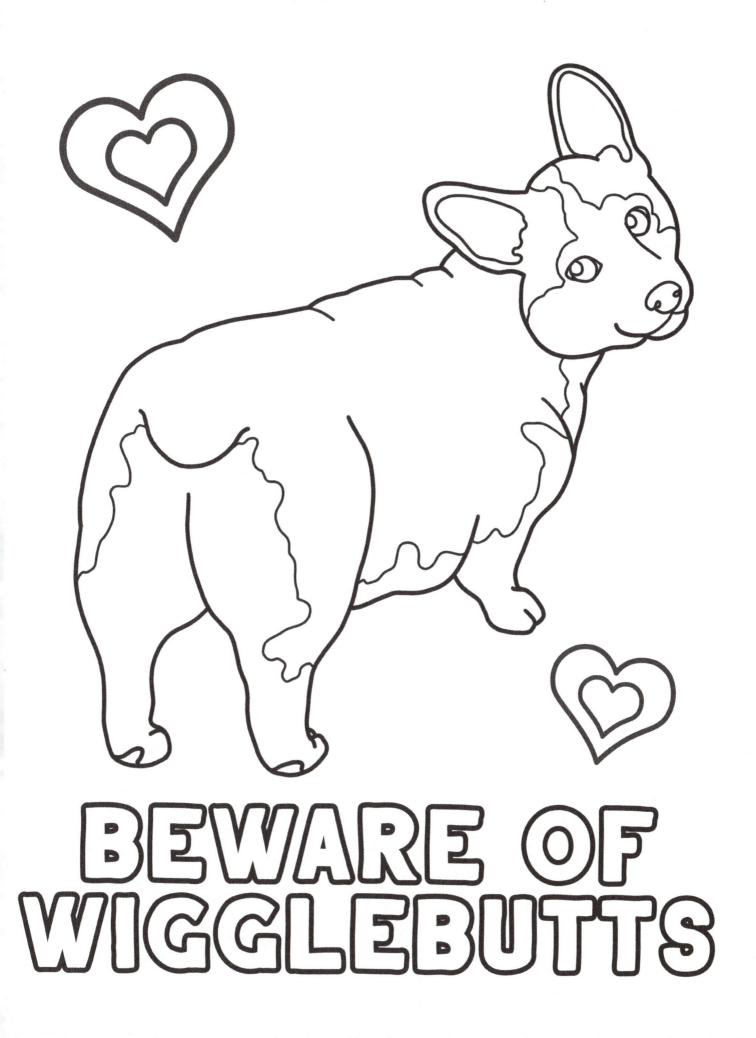

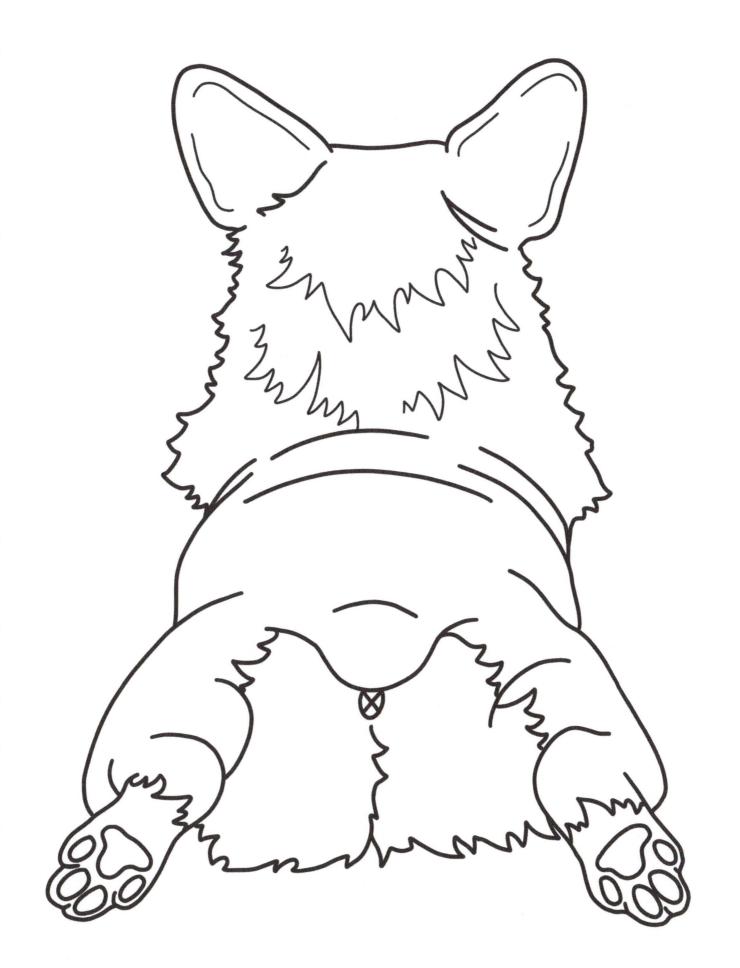

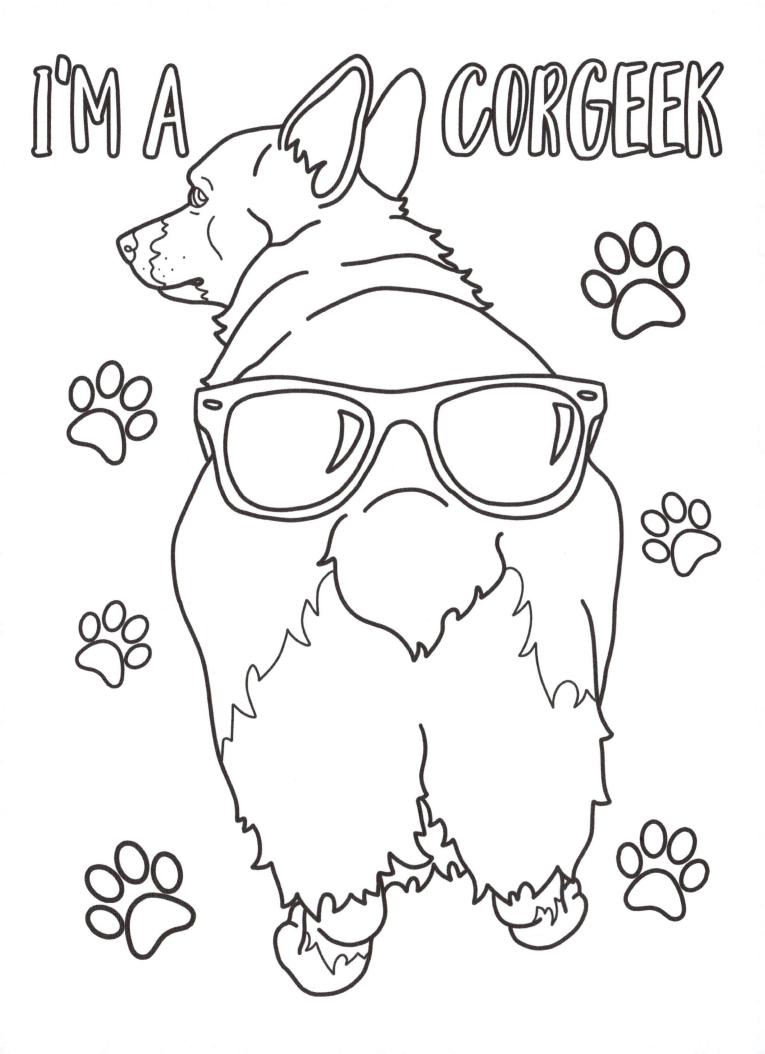

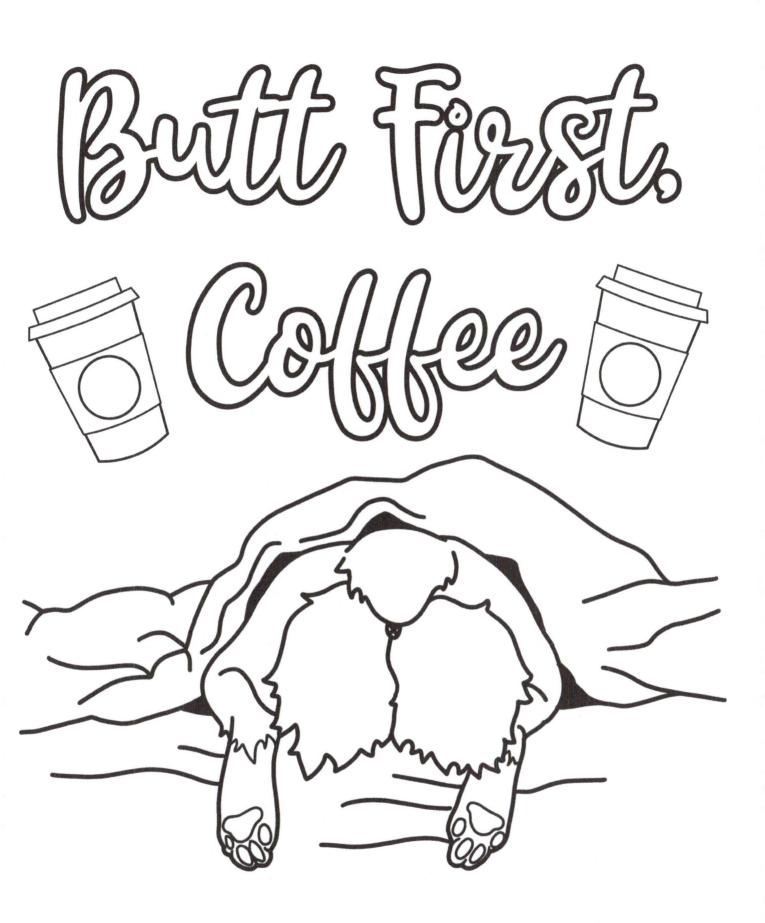

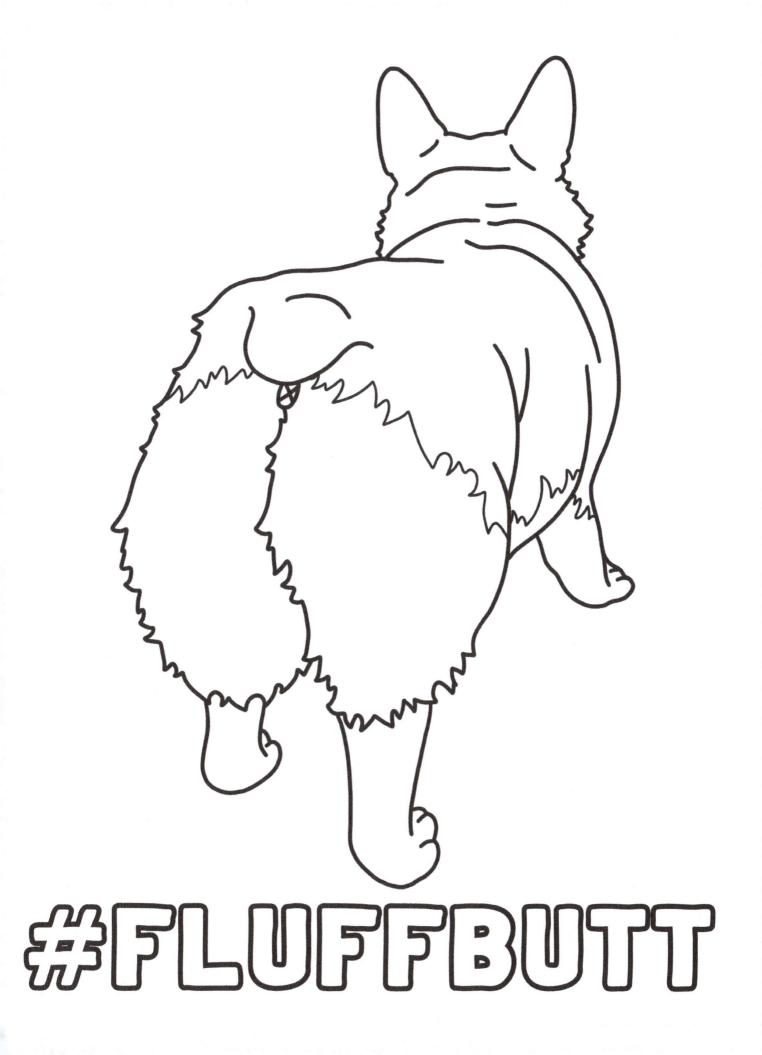

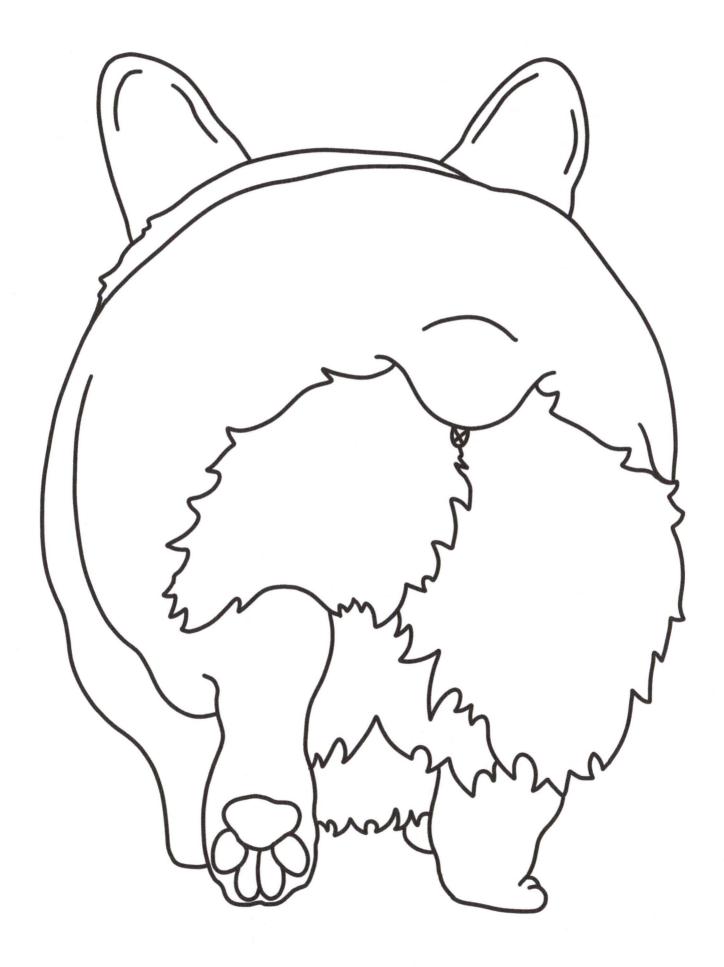

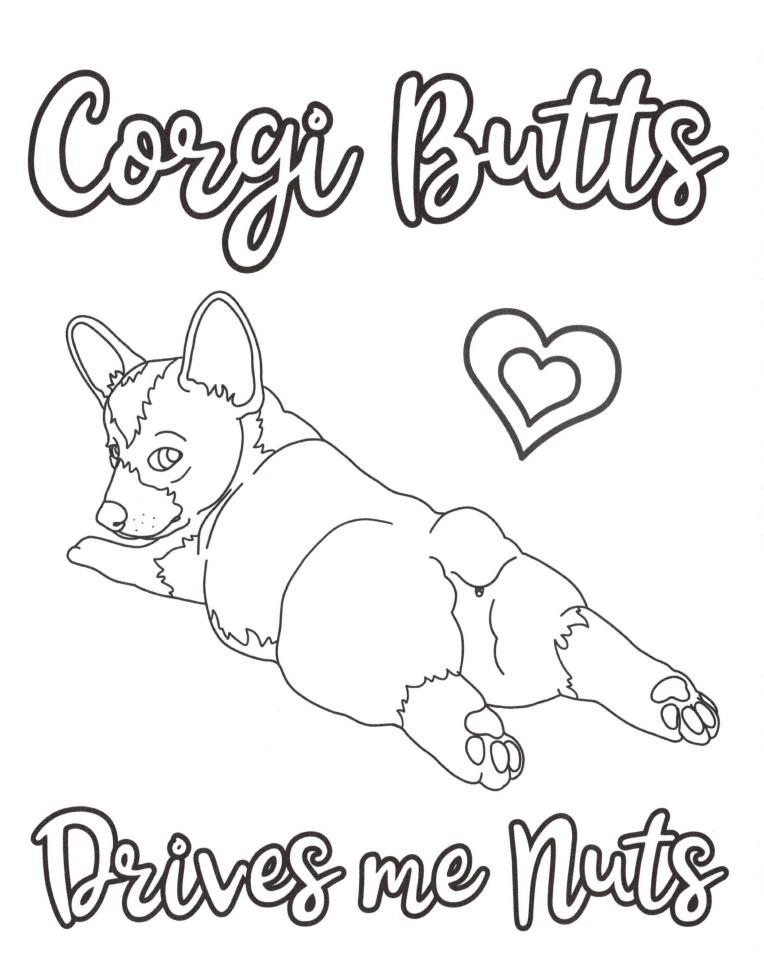

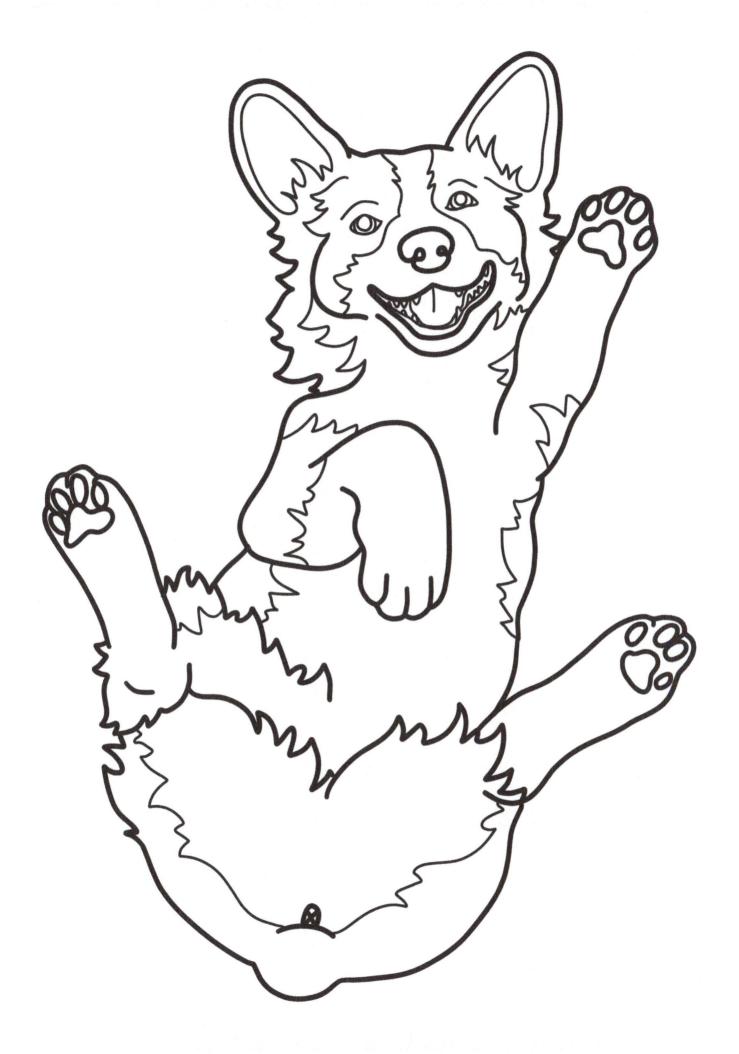

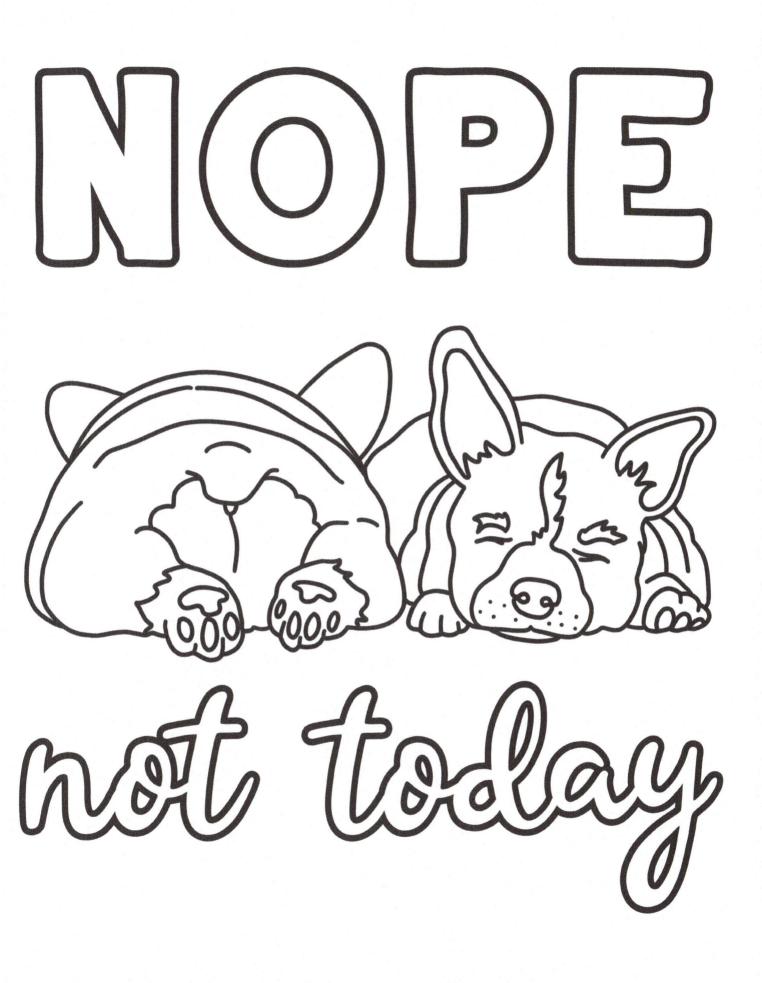

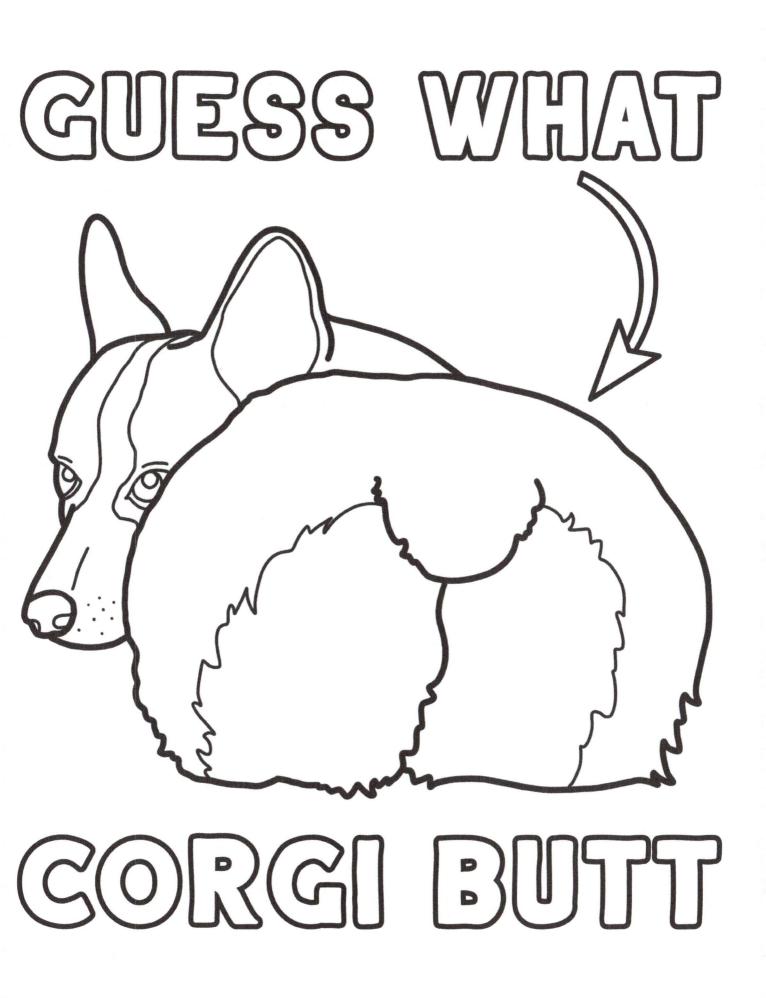

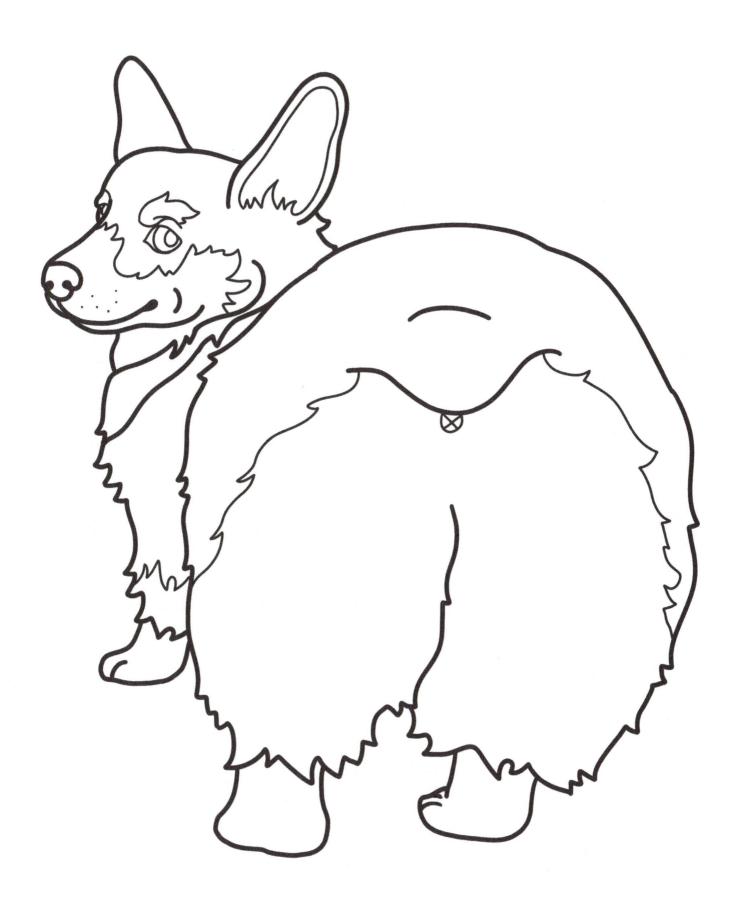

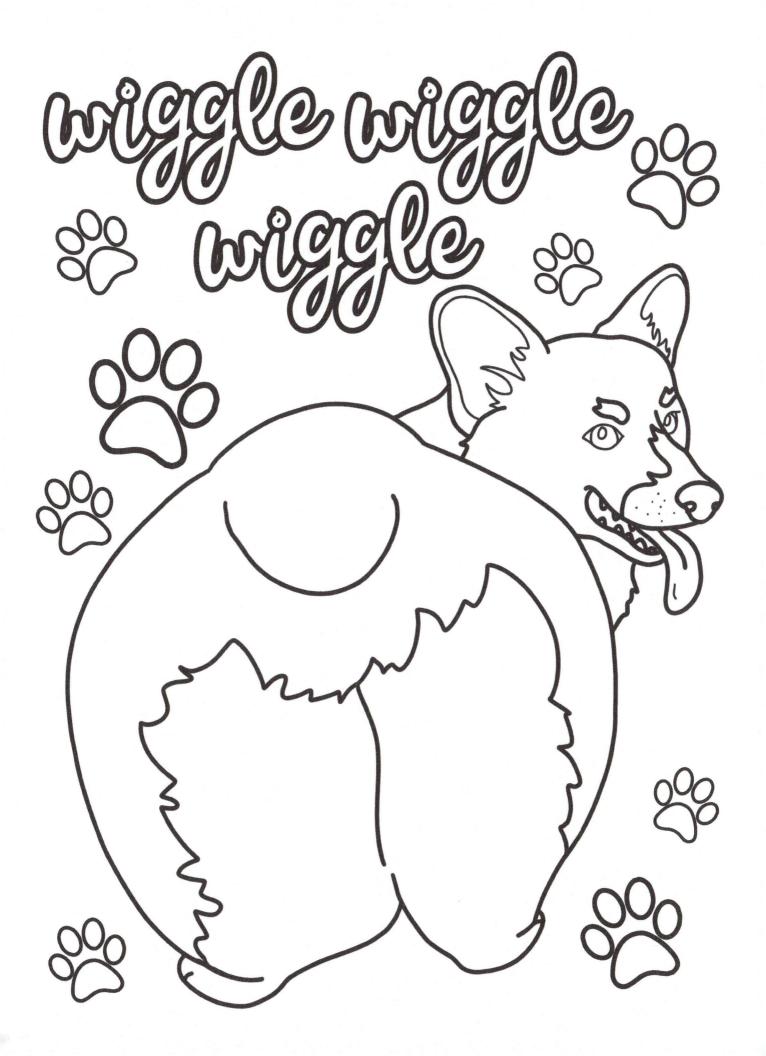

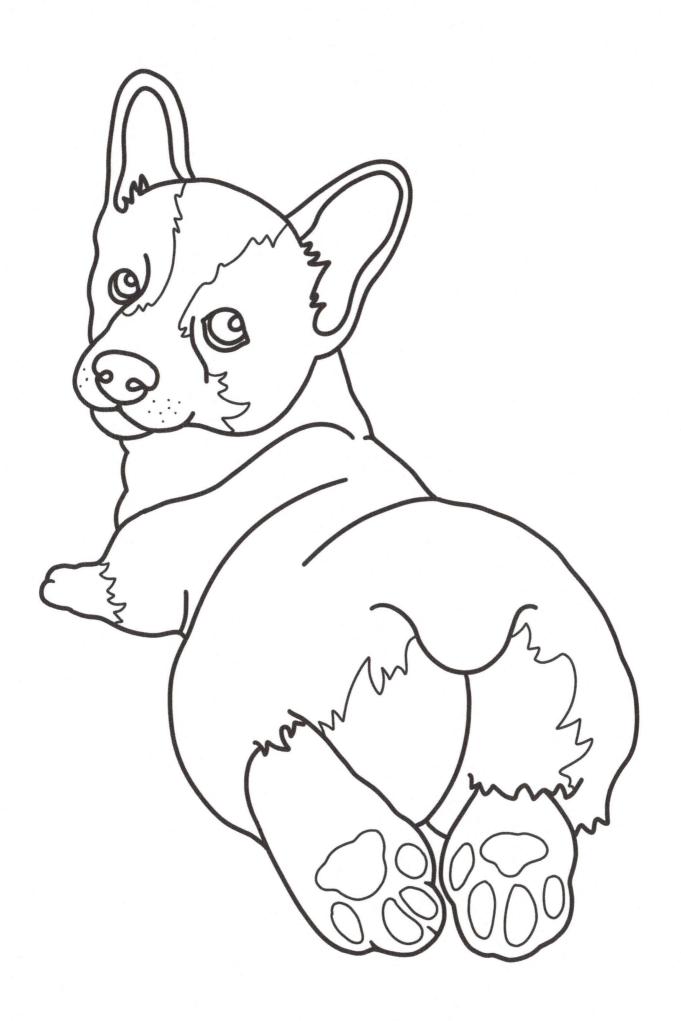

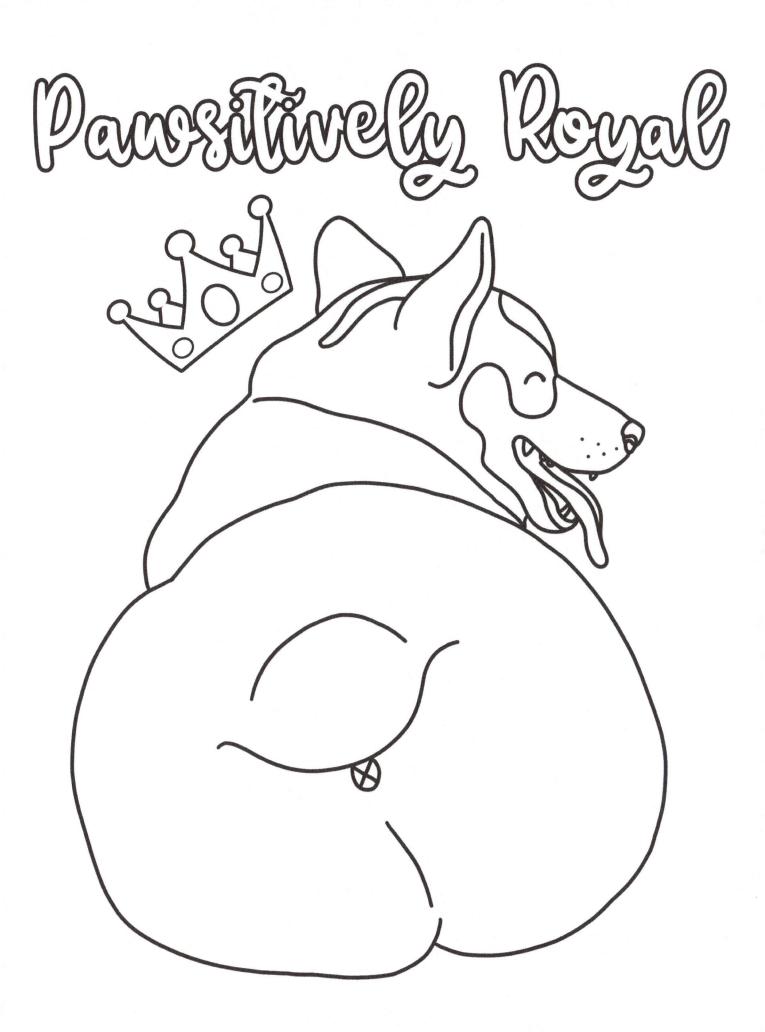

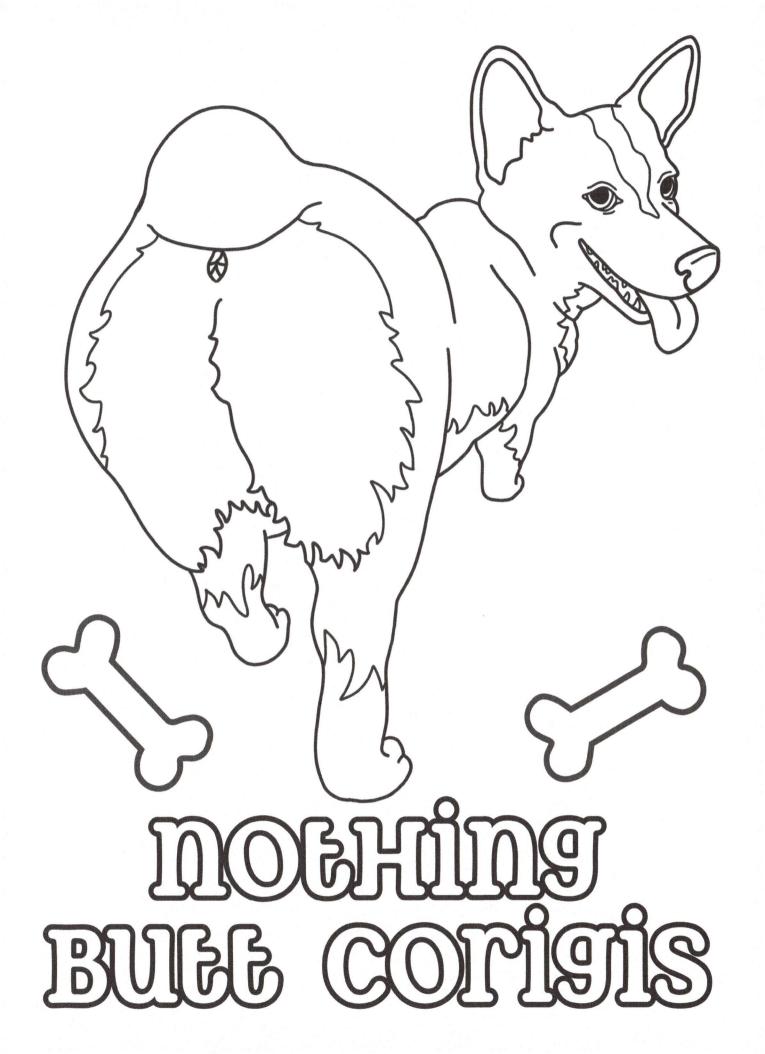

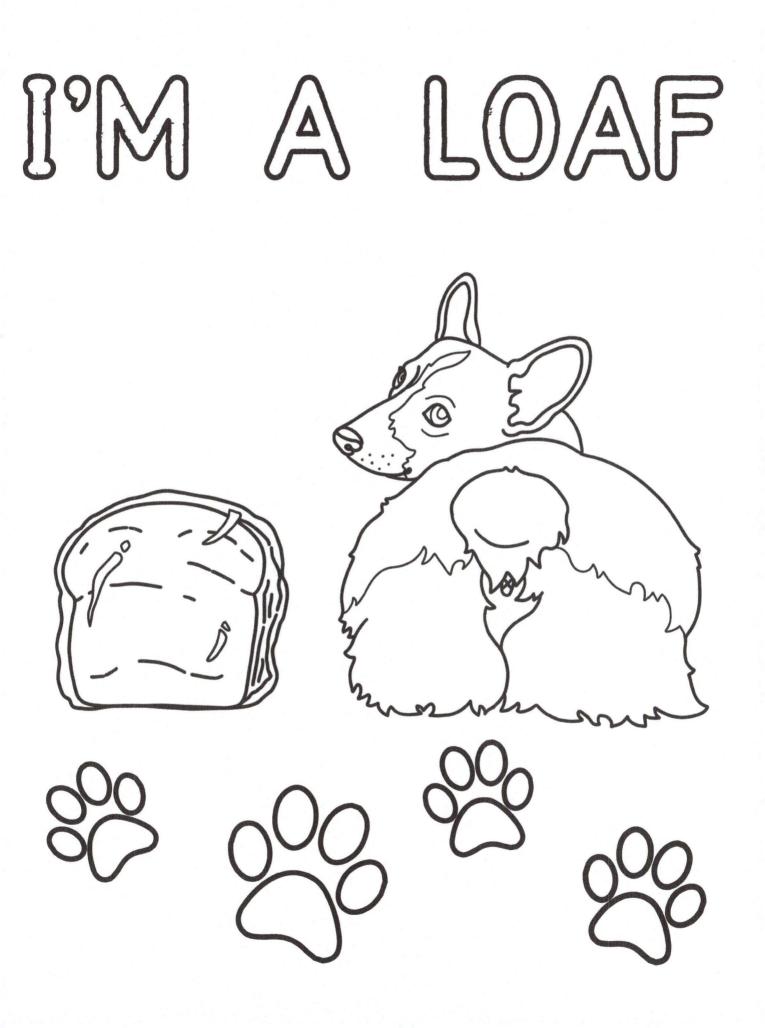

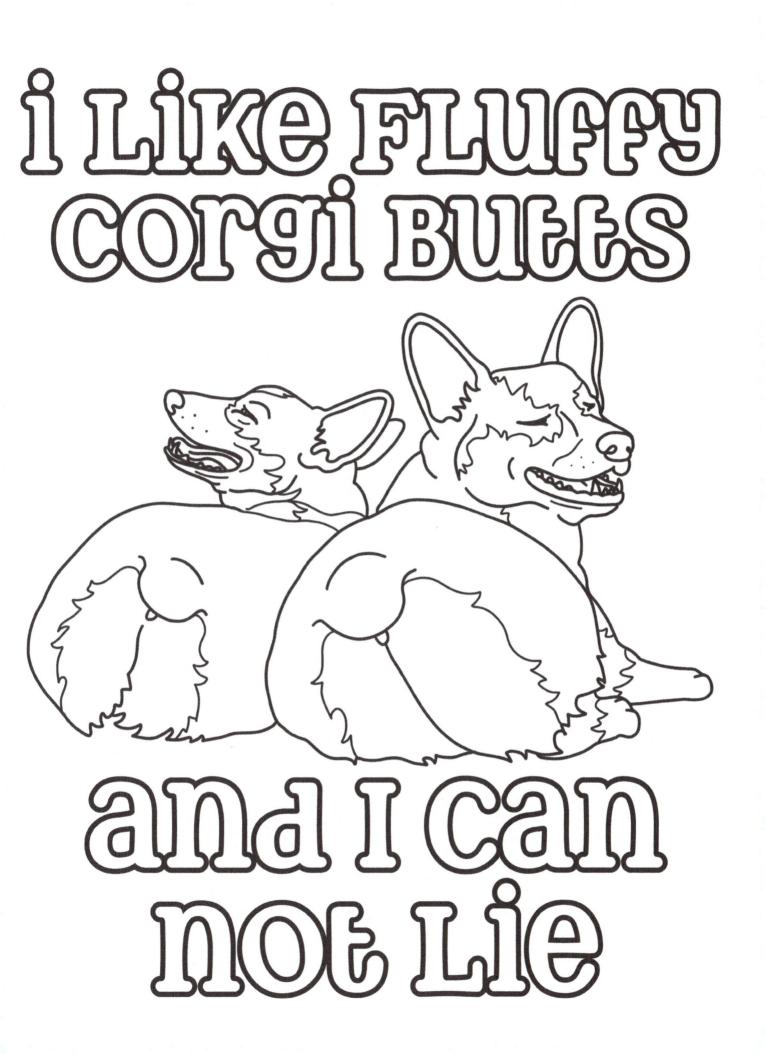

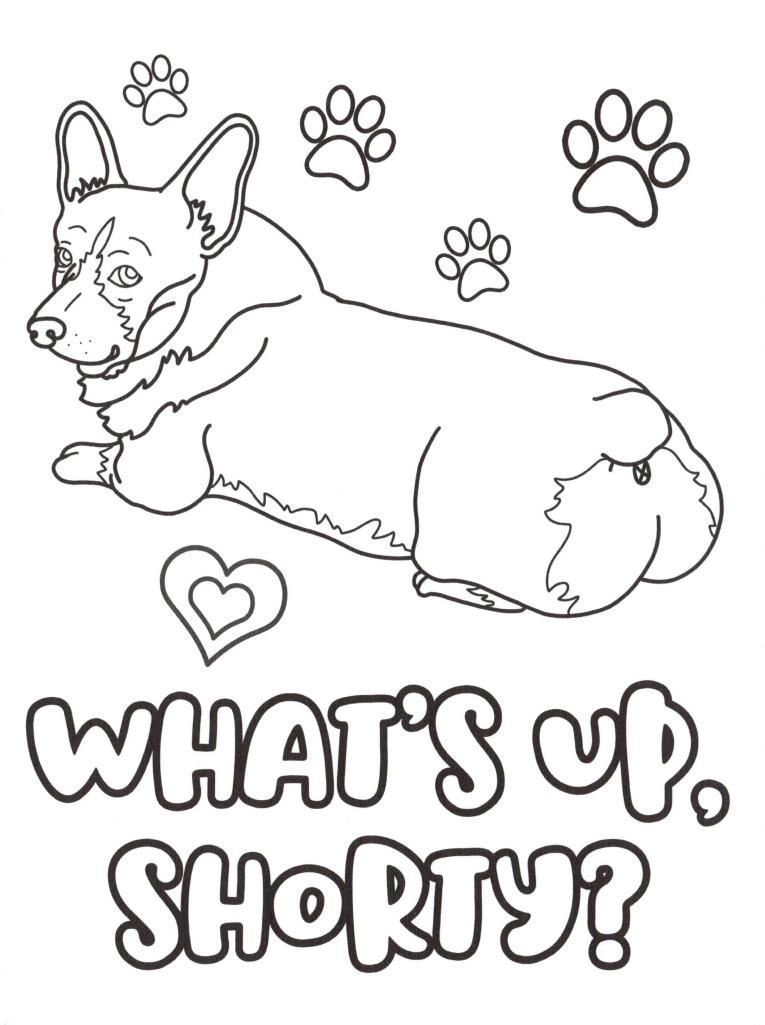

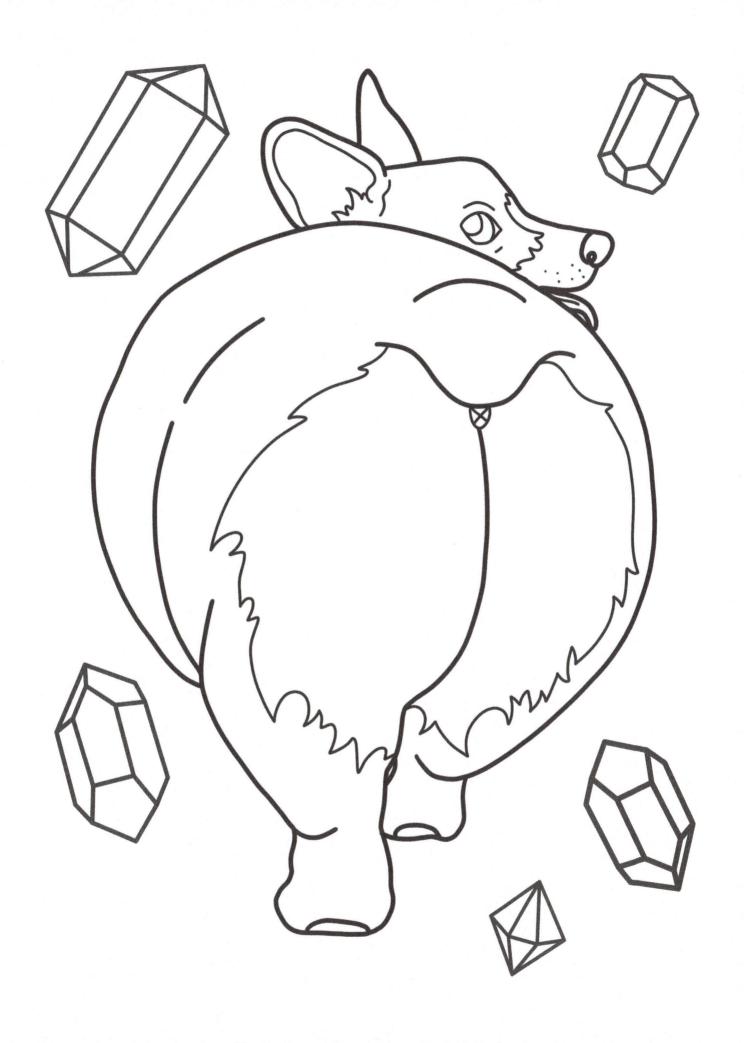

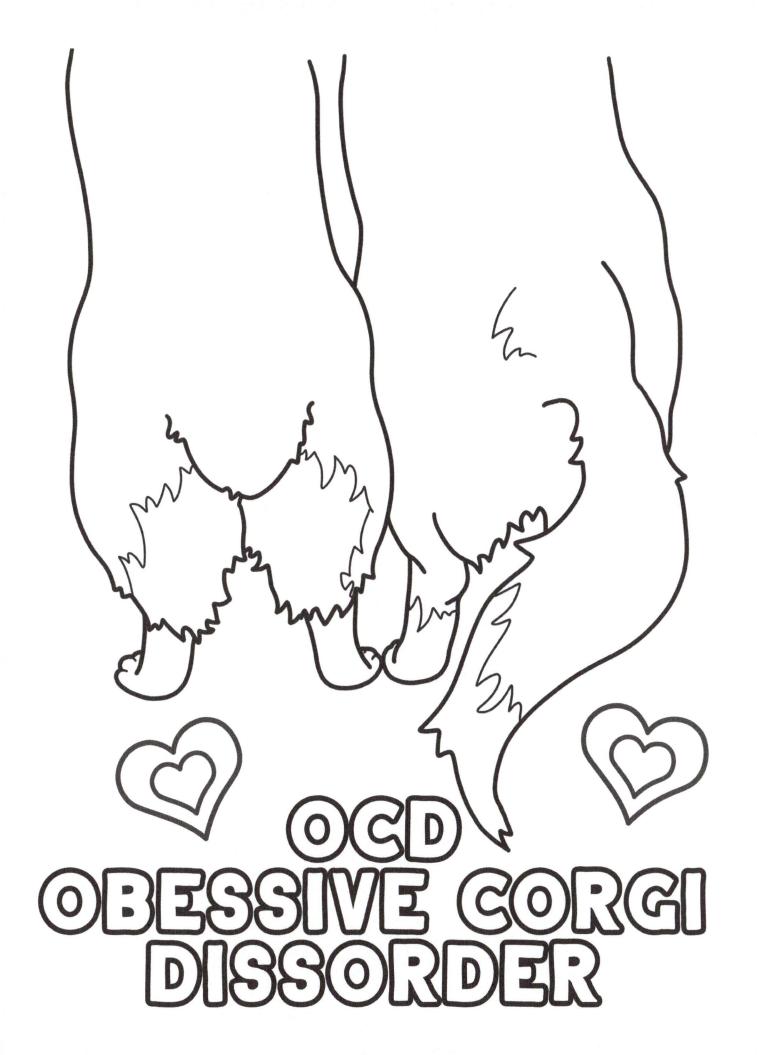

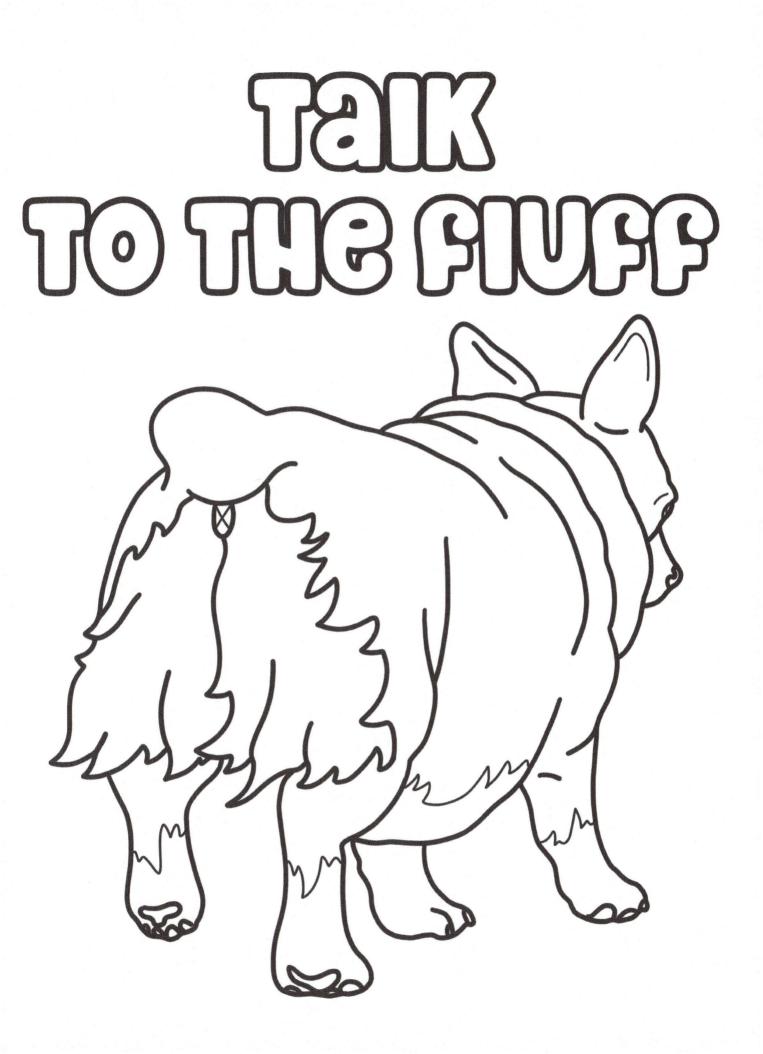

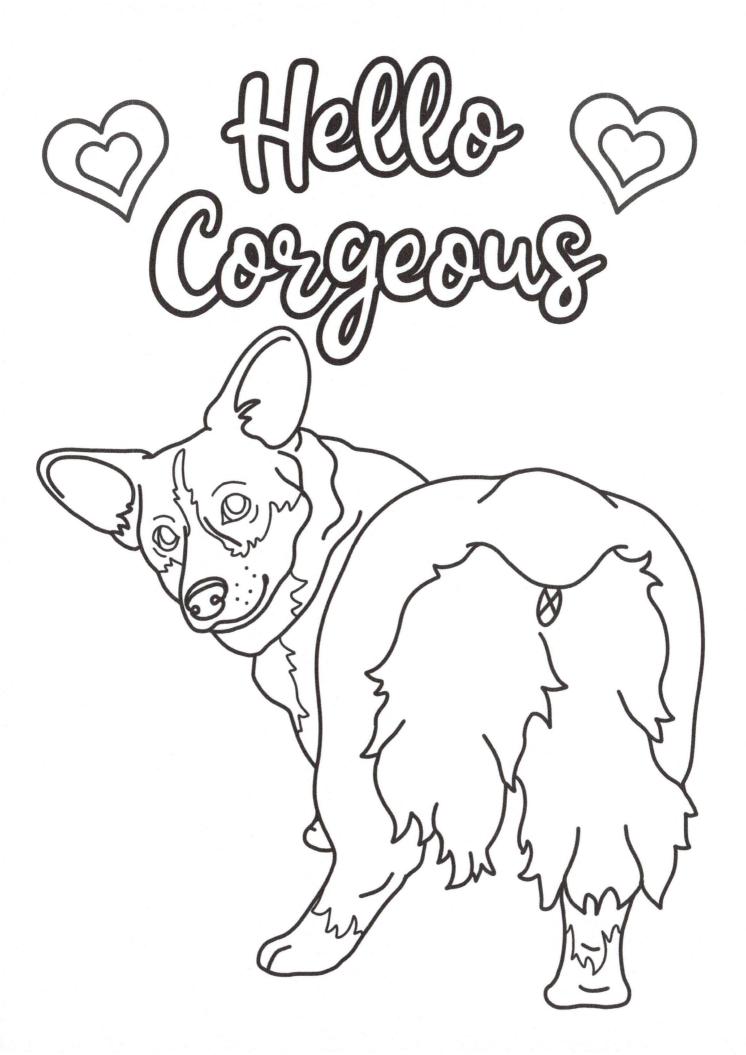

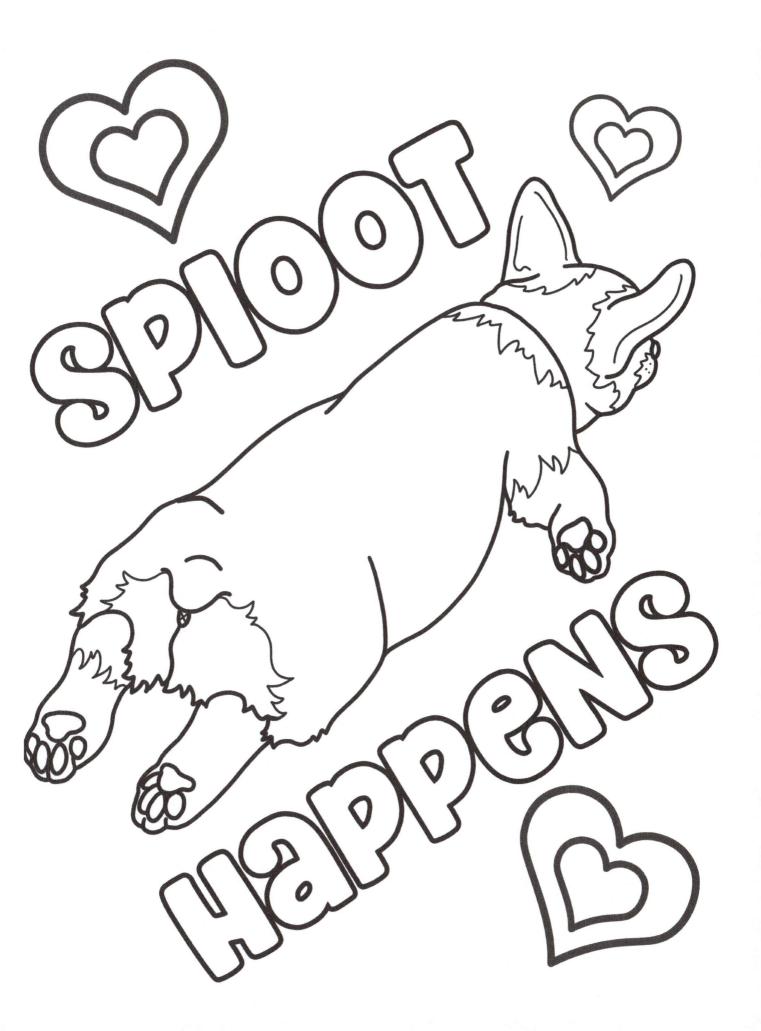

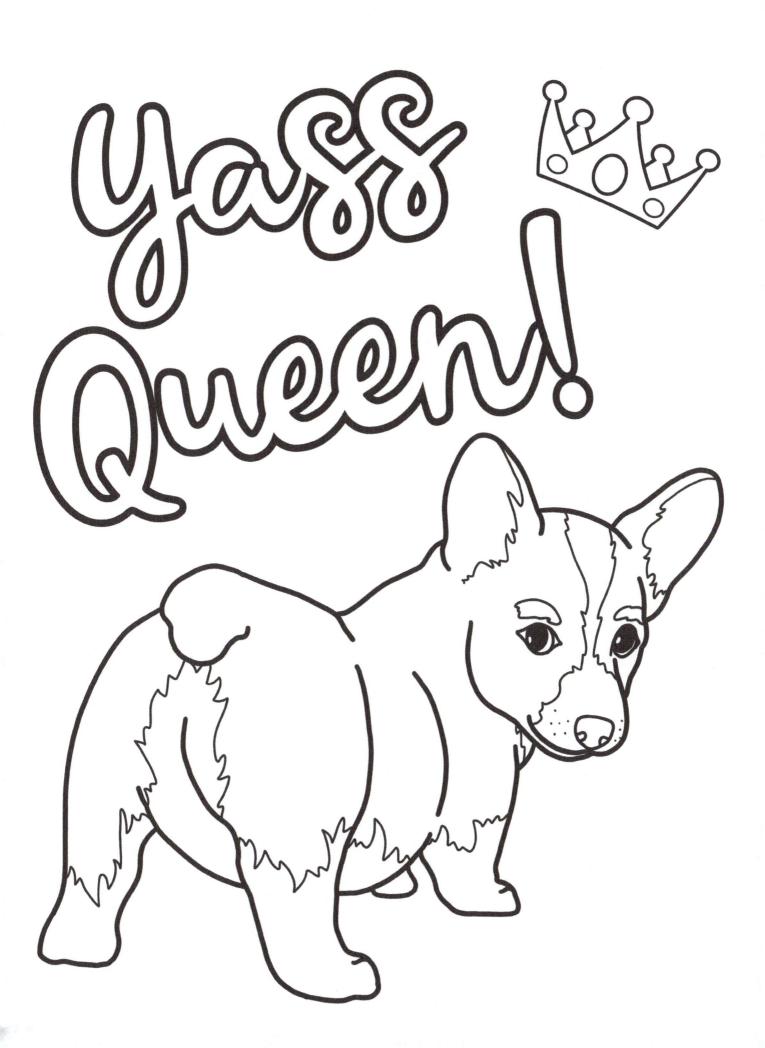

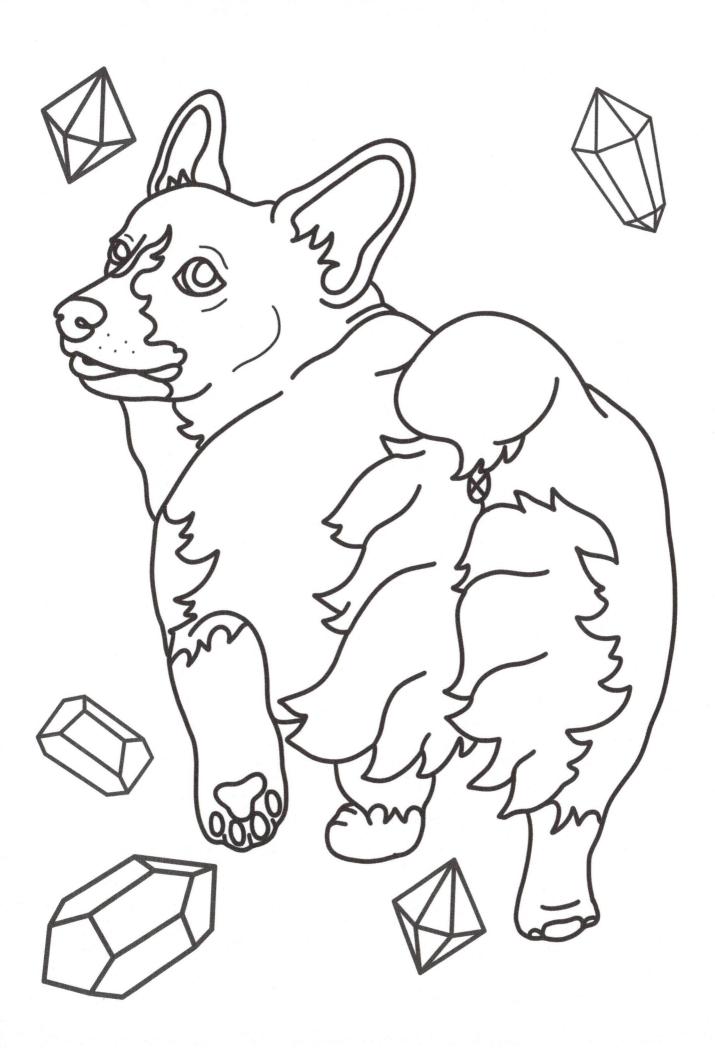

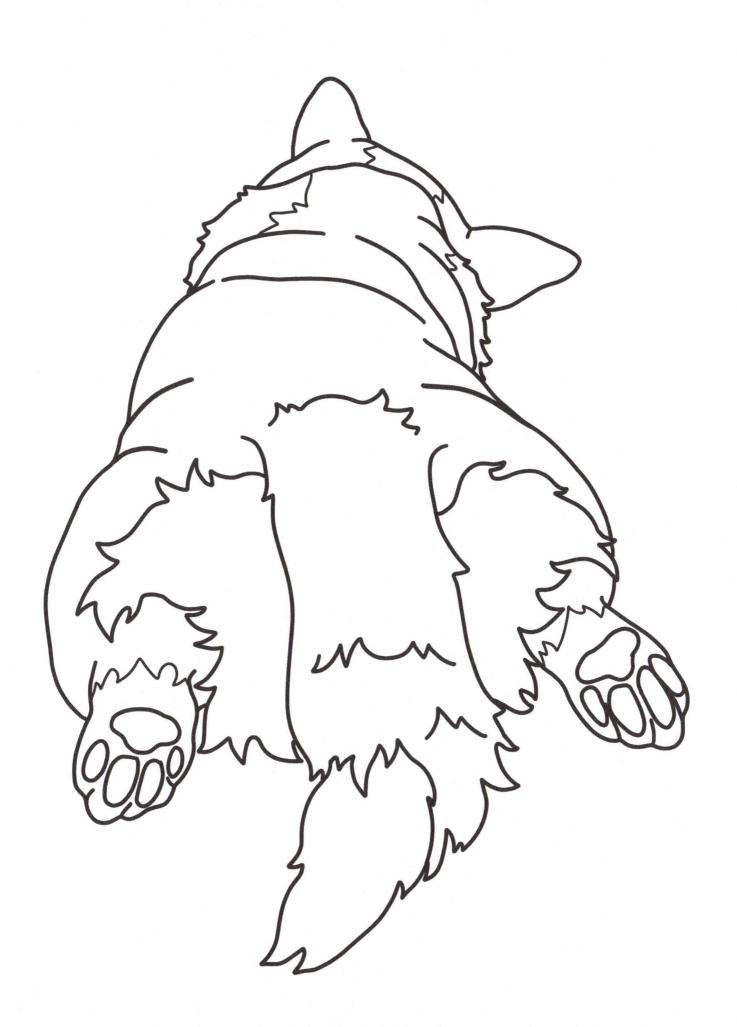

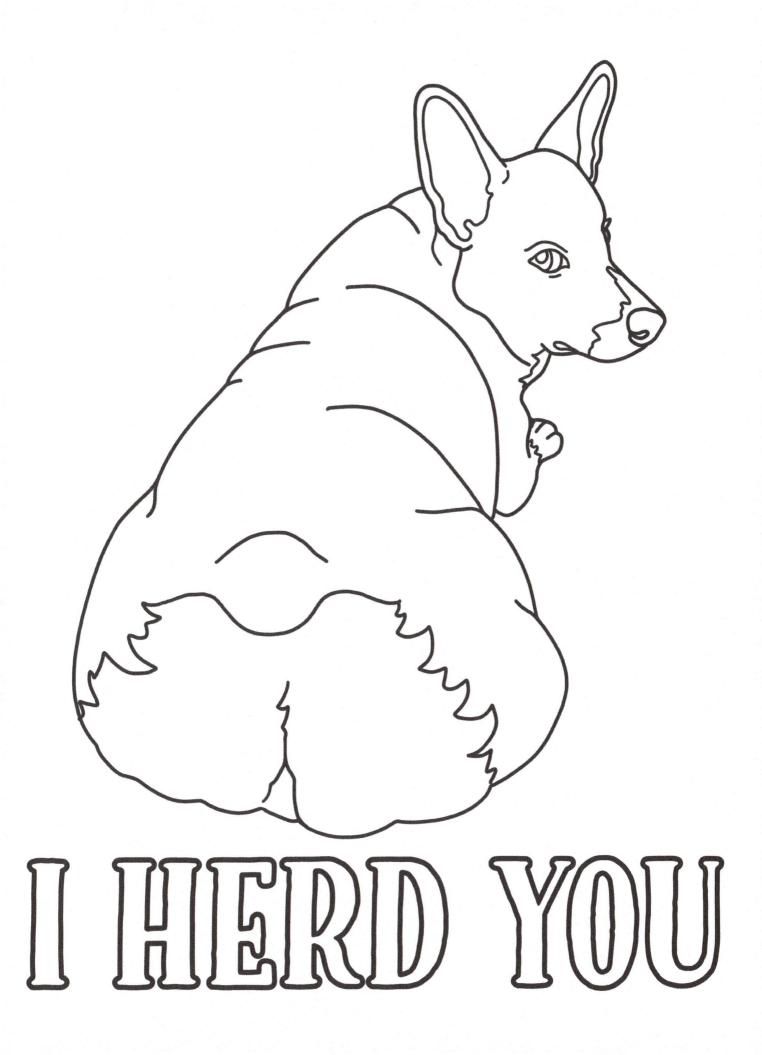

ALSO BY WHAT THE FARCE: